SWANSEA
HISTORY TOUR

First published 2017

Amberley Publishing
The Hill, Stroud,
Gloucestershire, GL5 4EP
www.amberley-books.com

Copyright © David Gwynn, 2017
Map contains Ordnance Survey data
© Crown copyright and database right
[2017]

The right of David Gwynn to be
identified as the Author of this work
has been asserted in accordance with
the Copyrights, Designs and Patents
Act 1988.

ISBN 978 1 4456 7316 5 (print)
ISBN 978 1 4456 7317 2 (ebook)

British Library Cataloguing in
Publication Data.
A catalogue record for this book is
available from the British Library.

Origination by Amberley Publishing.
Printed in Great Britain.

ACKNOWLEDGEMENTS

I have to thank the late Alan Jones, whose wonderful collection of postcards of Swansea provided many illustrations for this book. Also, I must thank Peter Muxworthy, whose equally wonderful collection I was allowed to raid for more illustrations.

My family, of course, deserve my gratitude for their help. My wife, Alicia, daughters Caitlin and Rebecca and my son, Steffan, all of whom contributed in various ways.

INTRODUCTION

Swansea, Dylan Thomas' 'lovely, ugly, town' and self-styled 'city by the sea', has had a long and varied history. Its actual origins are lost in the mists of time and are the subject of some debate. It is known that the Romans settled in the area, which has been proven by the existence of the remains of a villa at Oystermouth. It is possible that a ferry crossing somewhere along the lower reaches of the Tawe also had a few buildings to provide food and shelter for travellers. The most enduring legend concerns King Sweyn Forkbeard, a Viking ruler who was known to have been in the Bristol Channel area and may have established an encampment on an islet at the mouth of the River Tawe – hence the name Sweyn's Ey. In Welsh the city is known as Abertawe, meaning 'mouth of the Tawe'.

After the Norman invasion of south Wales at the end of the eleventh century, a castle was built on the west bank of a now strategically important river. A network of streets developed around the castle, which formed the heart of the little town. Today, this pattern of streets survives mostly intact.

As Wales became a more peaceful place, the town began to thrive. The population had remained under 2,000 from the mid-1600s to the mid-1700s, but by 1800 had grown to over 10,000. The reason for this was that the first stirrings of the Industrial Revolution were being felt in the Swansea area. The first copper works opened in the rural area to the north of Swansea, at Landore, around 1717. In 1764 the Cambrian Pottery opened on a derelict site near the present railway station.

There were coal mines already operating in the area, supplying fuel to these early works. Gradually, more copper works opened, together with tinplate, lead, zinc and arsenic. By the 1830s Swansea was recognised as

the most important copper-smelting centre in the world. It acquired the nickname 'Copperopolis', and from 1857 had its own Metal Exchange, which forty years later was given royal approval as the Royal Jubilee Metal Exchange. As new sources of ore were developed in South America, so the famous Copper Ore Barques of Swansea carried the ore from there to Swansea.

While the metallurgical industries were being born in the Swansea Valley, Swansea's other reputation was developing on the western edges of the town. In the eighteenth century Swansea was known as a spa resort, where genteel folk were able to take the waters, indulge in sea bathing, and relax at the Assembly Rooms. Georgian Swansea can still be traced around Cambrian Place and the Dylan Thomas Centre. Beau Nash, a contemporary of Beau Brumell, was a well-known dandy who frequented not just Swansea but also Bath and London.

The arrival of the railways, though, established Swansea as a leading industrial centre. Any plans to develop the seafront were hampered by the arrival of the Llanelly Railway in 1866, running their main line into Swansea Victoria station along the shore from Blackpill, alongside the already established Swansea and Mumbles Railway. What remained of the genteel Georgian Swansea was soon overwhelmed by the bustling, thriving town that had come to dominate the world's metallurgical industries.

The town suffered its worst blow during the Second World War, when, in February 1941, it suffered three nights of intensive bombing by the Luftwaffe. The centre of the city was largely destroyed, with many landmark buildings disappearing forever. From the rubble, a new town centre grew, with wider streets and new buildings. Since the war the town has strived to recover, not just from the bombs but also from the decline and globalisation of the metallurgical industries on which it depended.

In 1969, as part of the celebrations surrounding the investiture of the Prince of Wales, Swansea was granted city status. The Lower Swansea Valley Project led in the 1970s, '80s and '90s to the redevelopment of the derelict industrial sites at Landore, Hafod and Llansamlet, creating the Swansea Enterprise Park and Morfa Retail Park. The many changes to the commercial heart of the city are the focus of this book.

Brynmill

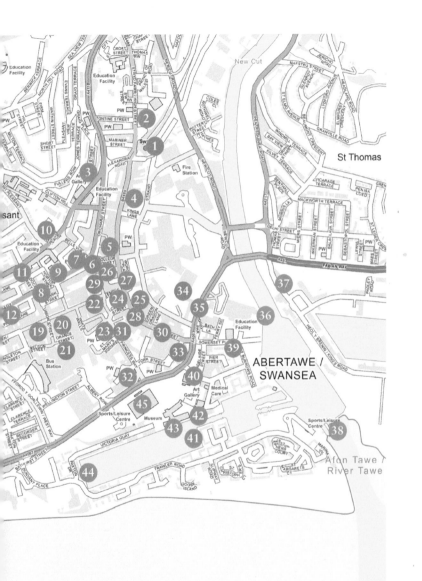

High Street Railway Station

1. SWANSEA RAILWAY STATION

High Street railway station was opened in 1850 by the South Wales Railway under the supervision of Isambard Kingdom Brunel. In 1863 the South Wales Railway amalgamated with the Great Western Railway, which, in turn, was nationalised in 1948. Recently the station has undergone a £7.6 million facelift that has improved not only the look of the station, but added facilities for the travelling public.

Swansea.

2. EMPIRE THEATRE, HIGH STREET

The Pavilion Theatre of Varieties opened in 1888 on a triangular site at the junction of High Street and Prince of Wales Road. In 1892 it was renamed the Empire Theatre, but in 1901 was renamed again as the Palace Theatre of Varieties. By 1908 it was screening films as part of the bill, and 1912 saw it being called the Swansea Popular Picture Hall and People's Palace. In 1923 it was back to live theatre and back to the Palace Theatre of Varieties. More change in 1937, when – now, as a cinema – it was called the New Palace Cinema, then just the Palace Cinema. In 1954 it was a live theatre again, and it was here in 1960 that Sir Anthony Hopkins made his first professional appearance on the stage. A few years later it was a bingo hall, then a private club before becoming a nightclub as its last gasp before closure by 2007. The building is now derelict.

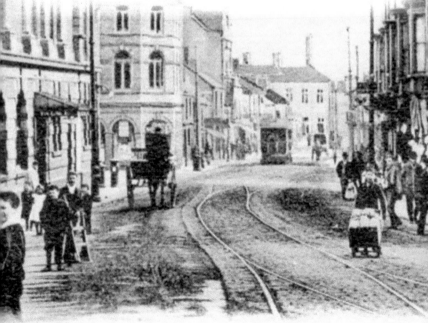

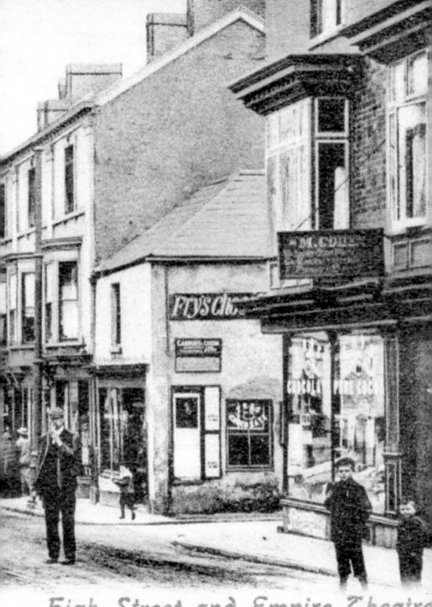

High Street and Empire Theatre

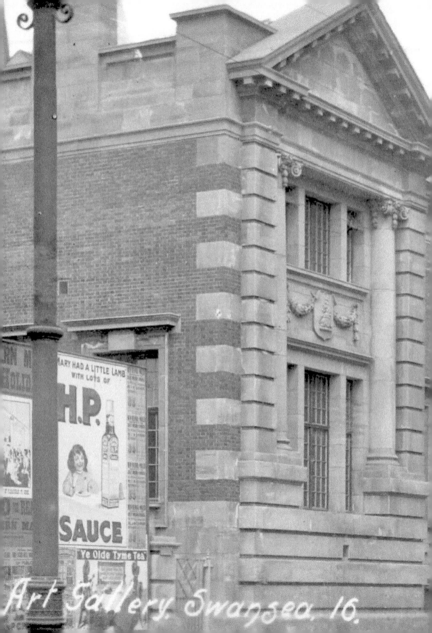

Art Gallery. Swansea. 16.

3. GLYNN VIVIAN ART GALLERY

Richard Glynn Vivian was a member of the wealthy Vivian family, who were local industrialists. In 1905 he offered his collection of paintings, drawings and china to the town. In addition he endowed the collection with sufficient funds to create a gallery, laying the foundation stone in 1909. The building was designed by Glenn Moxham, who also designed the town's new YMCA building. In 2011 the building was closed for a major refurbishment, but is now open to the public once more.

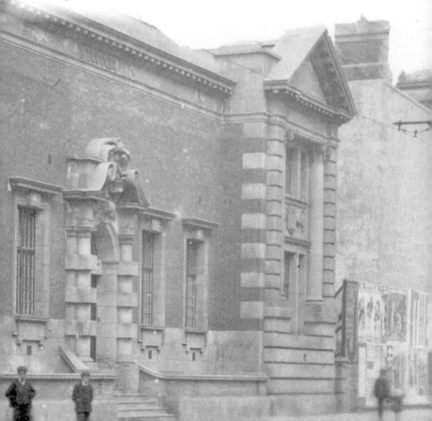

4. HIGH STREET

High Street was a busy shopping street in the early years of the twentieth century, with the Hotel Cameron an unmistakeable presence. F. W. Woolworth had their Swansea branch at the end of the street, and many people frequented their first-floor cafeteria. War damage, and indeed the needs of progress, meant that much of the street was redeveloped. Woolworths remained, in a new building, which is now occupied by Argos. Today, trees have been planted and the area has been given a facelift to make it more appealing to shoppers.

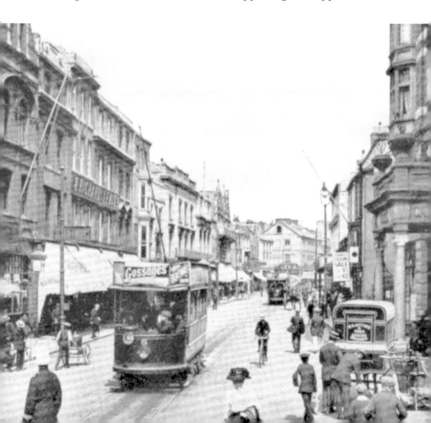

5. COLLEGE STREET

College Street is a short street that links High Street with Kingsway. At the time this photograph was taken some demolition work was in progress, although the new building would have had a short life as the whole area was destroyed in the Blitz. Notice that the Empire Theatre (in Oxford Street) took advantage of the temporary hoarding to gain some publicity!

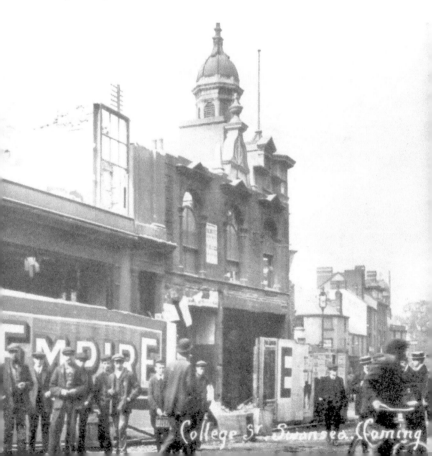

6. KINGSWAY ROUNDABOUT

This view of the roundabout at the eastern end of the Kingsway dates from around 1960. Then it was a haven of tended grass and flower beds. It became a sunken paved area with pedestrian underpasses for a number of years, before disappearing altogether to enable new roadworks to accommodate the ill-fated 'bendy buses' that were in use for a few years from 2011.

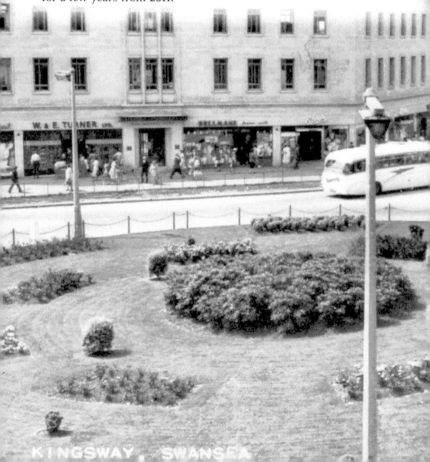

KINGSWAY, SWANSEA

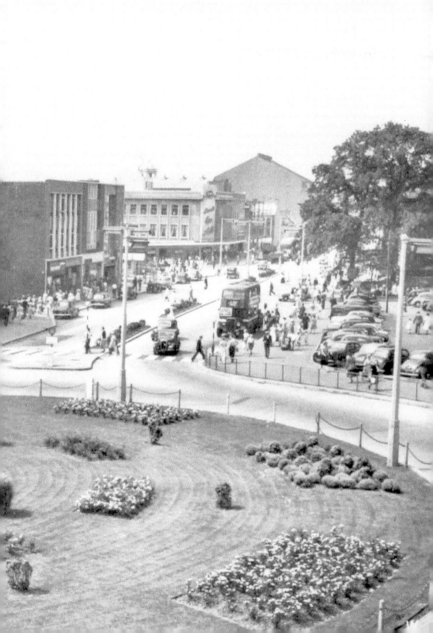

7. DRAGON HOTEL

The previous page shows the Kingsway roundabout, and on the right-hand side of the photograph, from 1960, a temporary car park could be seen. That site is now occupied by the prestigious Dragon Hotel.

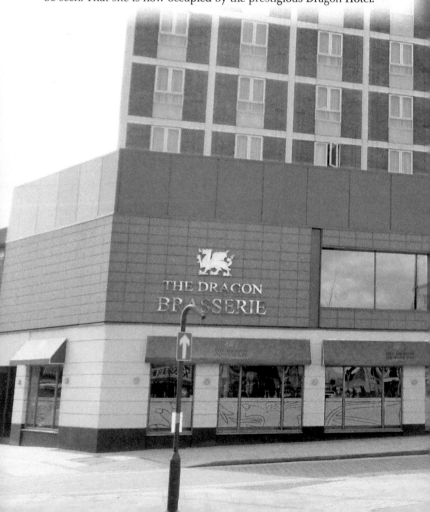

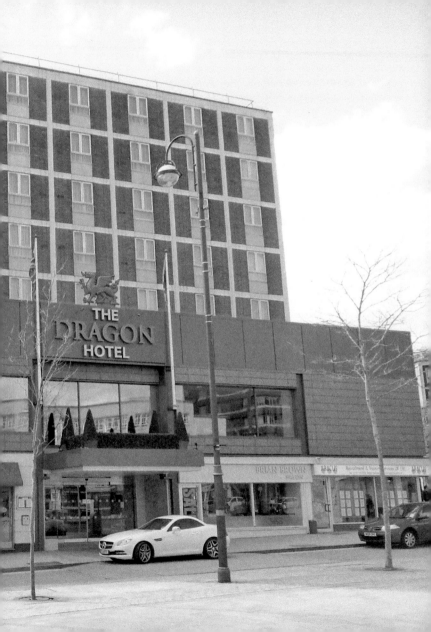

8. KINGSWAY

After the Second World War, Swansea's town centre was a wasteland littered with bomb sites. Rebuilding was destined to take over twenty years. Kingsway, named for King George VI, was a broad dual carriageway that replaced both Northampton Place and Gower Street.

9. MOUNT PLEASANT BAPTIST CHURCH

This church was built in 1825–26 and was successively enlarged in 1874–76, 1885, 1904 and again in 1904–05. It used to face Gower Street but, since the redevelopment of the area, now faces Kingsway.

10. MOUNT PLEASANT AND DE LA BECHE STREET

Mount Pleasant Hill climbs up from De la Beche Street to Townhill and Mayhill. Halfway up the hill was the technical college, formerly Swansea Grammar School, *alma mater* of Dylan Thomas. Today it is part of the University of Wales Trinity St David's. Out of the picture on the left stand the buildings of the former Dynevor School, which, since closure, have also become part of the University of Wales Trinity St David's.

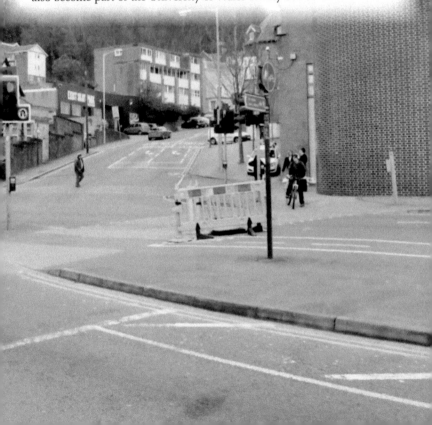

11. CRADOCK STREET

There have been a number of changes to Cradock Street over the years. The building on the right, closest to the camera, made way for a branch of the Trustee Savings Bank, which is now part of the Lloyds TSB Banking Group. Further along on the right can be seen the portico of the Albert Hall.

This opened as a cinema and operated as such until around 1980, before becoming the Top Rank Bingo Hall, which was later transformed into a Mecca Bingo Hall until its closure in 2007. The building is now derelict, although efforts are ongoing to restore and reopen it.

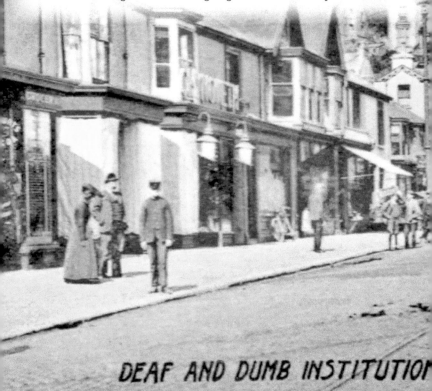

DEAF AND DUMB INSTITUTION

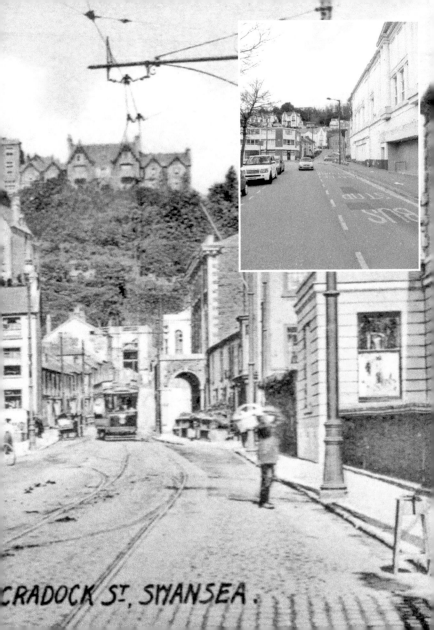

CRADOCK ST. SWANSEA.

12. PLAZA CINEMA

The Plaza was the largest cinema to have been erected in Wales at the time of its opening in 1931. It was the first independent cinema in Wales to have CinemaScope and stereophonic sound, these being fitted in 1953. In 1965 the cinema was closed and demolished to be replaced by the state-of-the-art Odeon. That in turn was closed and the building became a nightclub. I have included an inset showing the building as the Oceana nightclub, but as I write this in early 2017 demolition is underway, although it is not yet clear for what the vacant site will be used.

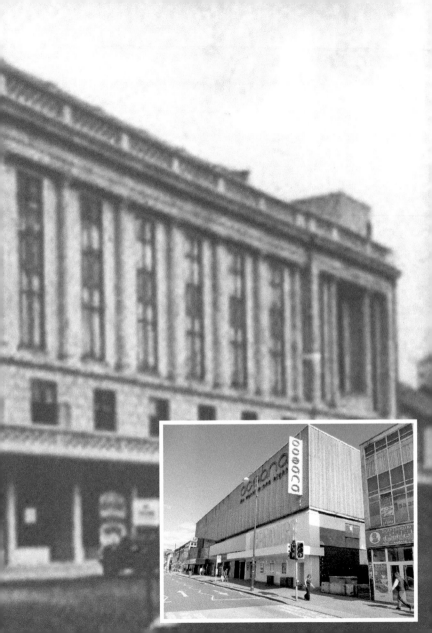

13. NORTHAMPTON PLACE

This pleasant street of villas and town houses was actually closer to the centre of town than might at first be assumed. The high trees hide the YMCA building on St Helen's Road, and behind the photographer is Gower Street. The whole area was destroyed in the Blitz and today is part of the Kingsway.

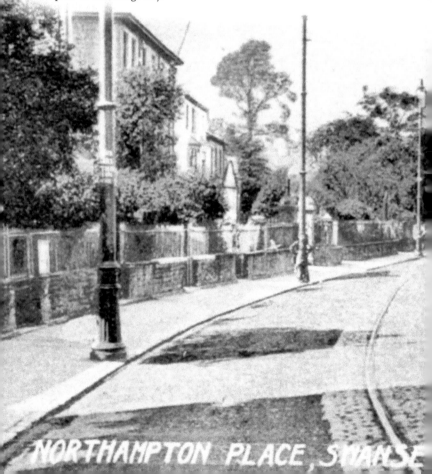

NORTHAMPTON PLACE, SWANSE

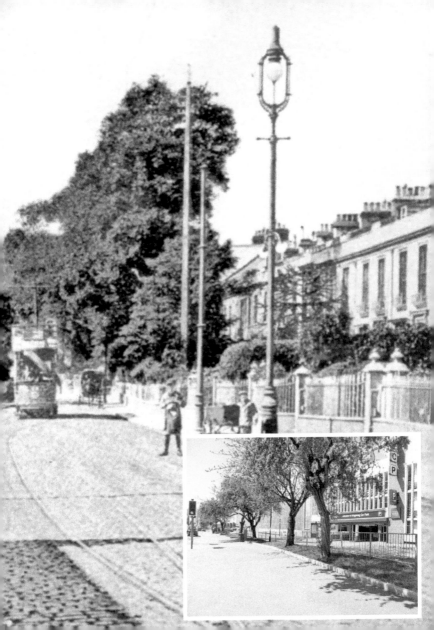

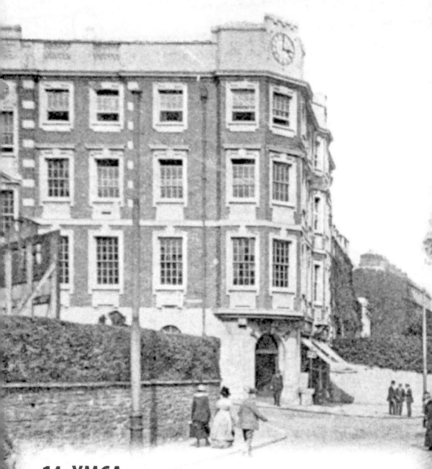

14. YMCA

The new YMCA stands proudly at the end of St Helen's Road, dominating its immediate neighbours. The shops on the right-hand side of the road have mostly been replaced with more recent buildings. The mass of trees in the distance hides the villas of Northampton Place.

ST. HELEN'S ROAD, SWANSEA.

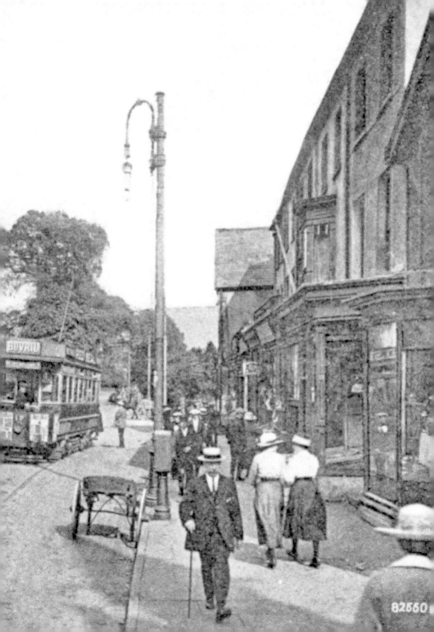

82550

15. ST HELEN'S ROAD

St Helen's Road has always been a busy arterial road leading from the commercial centre of the city to the Guildhall and seafront. In recent years it has become home to a number shops selling exotic fruits and vegetables and catering to the needs of the city's immigrant community.

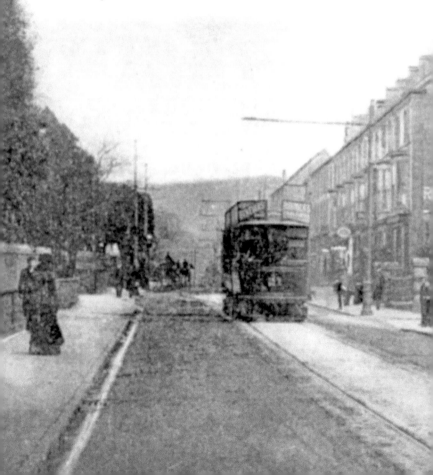

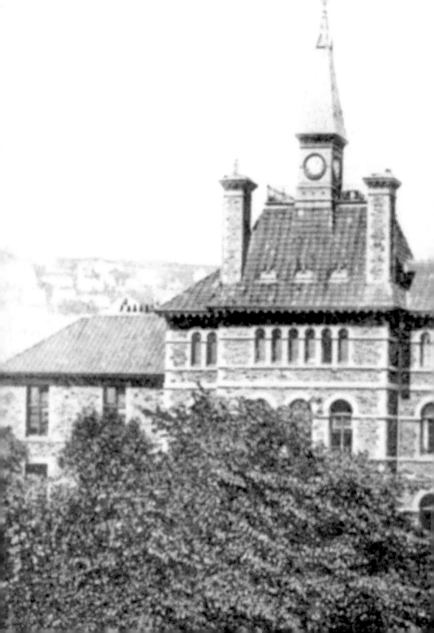

16. SWANSEA HOSPITAL/ HOMEGOWER HOUSE

First founded in 1814 as the Swansea Dispensary, it then became known as the Swansea Infirmary between 1817 and 1867. From 1872 to 1889 it had the title Swansea Hospital, and from then to 1948 was called the Swansea General and Eye Hospital. It was closed in 1968 and was replaced by Singleton Hospital. Converted into flats for older people, it is now called Homegower House.

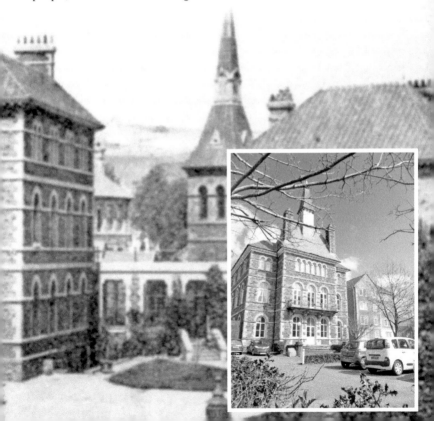

17. GUILDHALL

As the boundaries of the borough of Swansea were extended in 1918, the existing civic buildings proved quite inadequate for the demands being placed on them. After some years of deliberation, a site was chosen on the eastern edge of Victoria Park, and a new Guildhall built. Designed by Percy Thomas, an architect from Cardiff, it was opened by the Duke of Kent on 23 October 1934. The Brangwyn Hall houses the famed Brangwyn Panels, the work of Sir Frank Brangwyn and originally intended for the House of Lords.

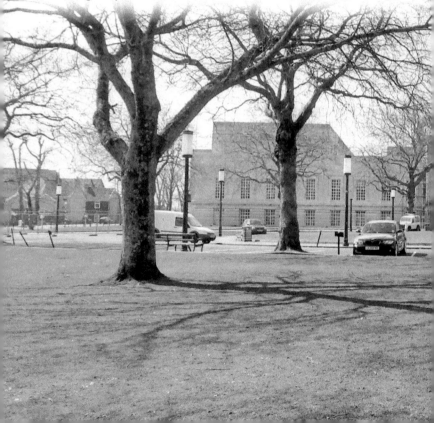

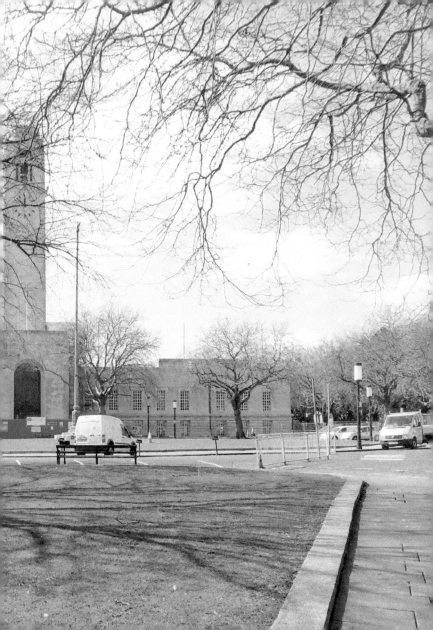

18. VICTORIA PARK

Although much reduced by the building of the Guildhall in 1934, Victoria Park still provides many facilities for use by the general public. There is a bowling green and a skate park. Also note the large mural wall celebrating the life of Dylan Thomas.

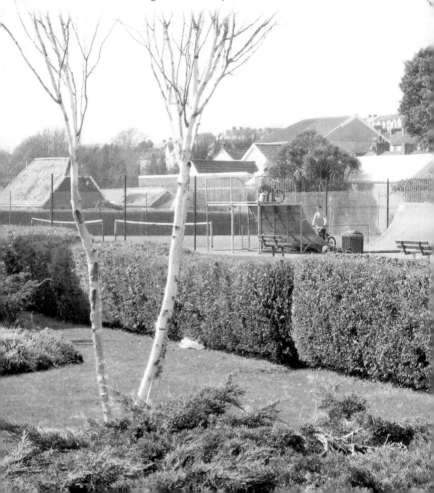

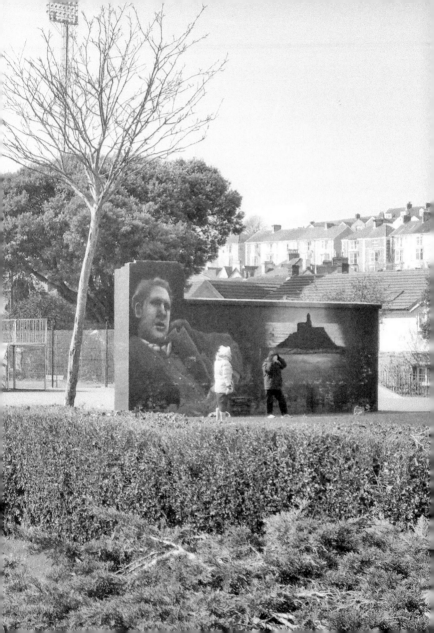

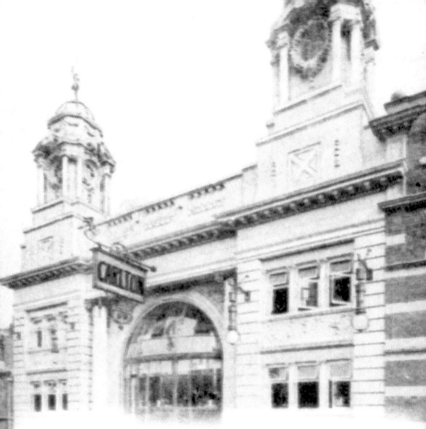

19. CARLTON CINEMA

Opened in 1914, next door to the Empire Theatre, the Carlton Cinema had an impressive façade with a large bay window, behind which the stairs to the first and second floors were contained. These stairs led to the Carlton Café, which was another part of the R. E. Jones Café Empire Theatre. The cinema was closed in 1977 and the auditorium was demolished to make way for the building of the Waterstones bookshop. The listed façade was retained and has been cleaned and restored to its former glory.

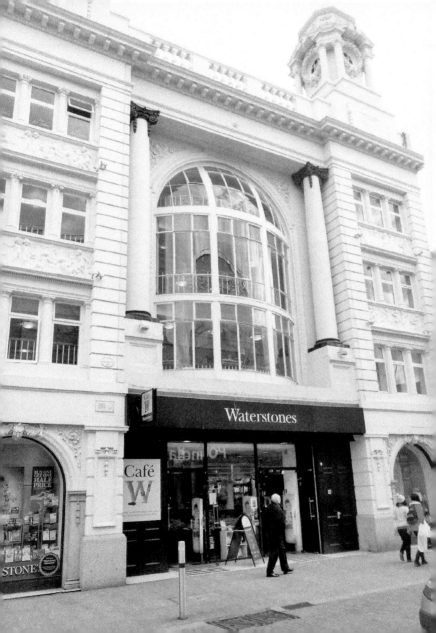

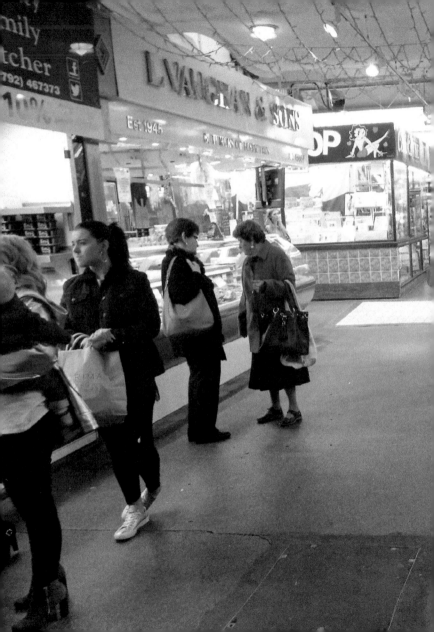

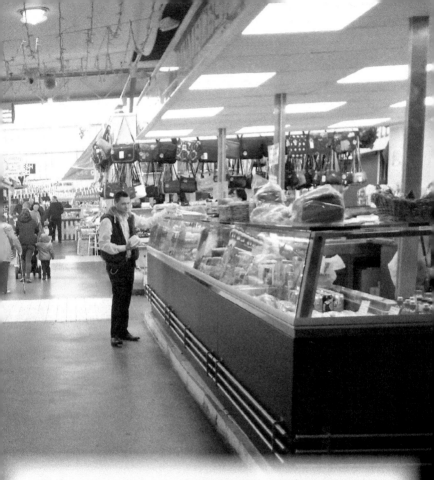

20. SWANSEA MARKET

Producers from all around Swansea and Gower came to the market to sell their goods, including vegetables, eggs, flowers, the world-famous Penclawdd cockles and much more. Today, the only Gower vegetable producer still with his own stall in the market is Neil Evans from Oldwalls.

21. THE QUADRANT

The Quadrant Shopping Centre is adjacent to Swansea Market, having been built on the land that had been home to the temporary market while the current market was being built. It provides an undercover link between the bus station and the market, and is now the central feature of Swansea's shopping quarter.

22. OXFORD STREET

Oxford Street has become Swansea's main shopping street. A wide, pedestrianised thoroughfare, it is an ideal location for temporary outdoor markets. There is an annual Christmas market. This picture shows a French market, and there are local produce markets and occasionally a German market too.

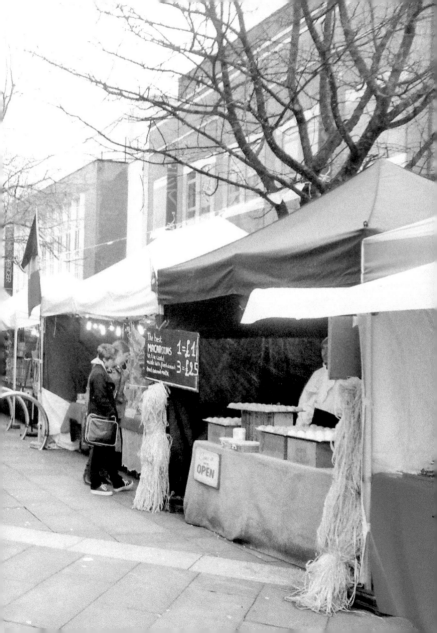

23. ST MARY'S CHURCH

St Mary's Church was founded in the twelfth century, but has undergone several restorations and rebuilds in its history. Between 1895 and 1899 an impressive Gothic-style building, designed by Sir Arthur Blomfield, replaced the previous – much-criticised – structure. The church suffered considerable damage during the Blitz, and was rebuilt between 1954 and 1959 by L. T. Moore and Sir Percy Thomas, who followed Sir Arthur Blomfield's original design plans.

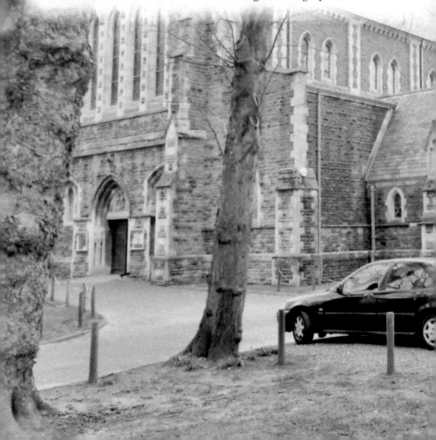

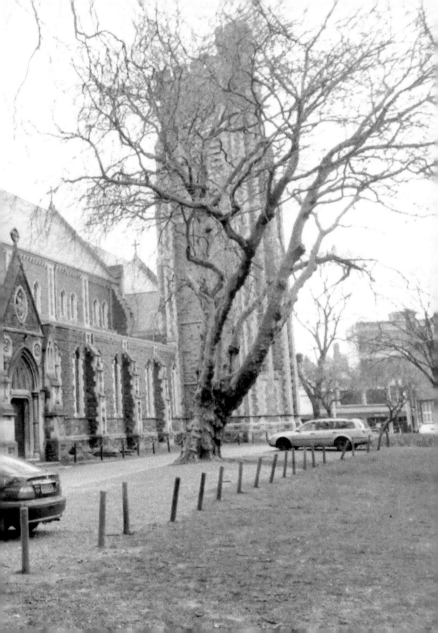

24. CASTLE GARDENS

As part of the redevelopment of the centre of the town, open spaces were included, inspired, arguably, by the 'Garden City' movement of the interwar years. Castle Gardens, occupying the site of the Ben Evans department store, was an oasis of lawns and flower beds with pathways and seats. Nowadays, the area has been paved over; there is water feature and a big screen to relay news and major events.

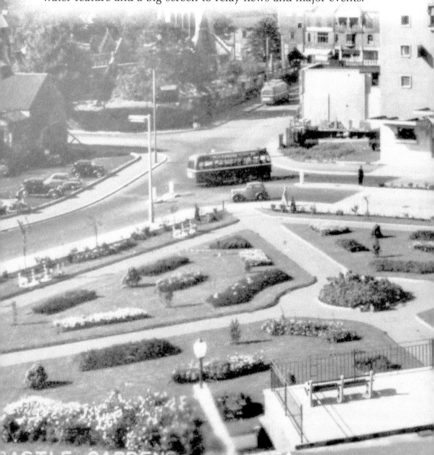

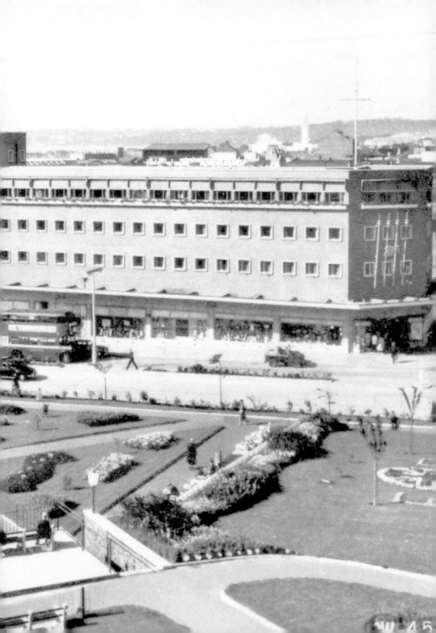

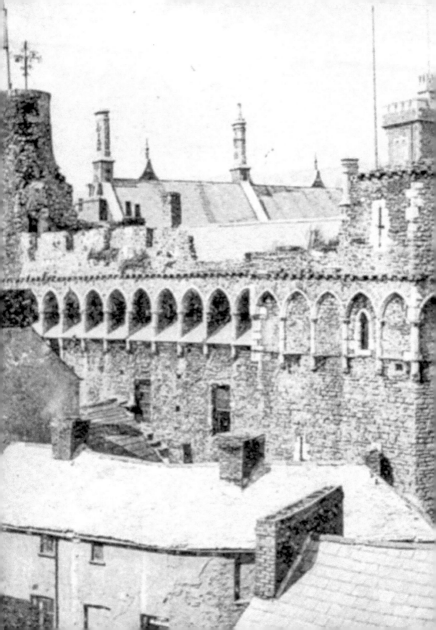

25. SWANSEA CASTLE

What remains of the castle dates largely from the early fourteenth century, when the Bishop of St David's adapted the building to form a palace similar to that already in use at St David's in Pembrokeshire. After several hundred years of neglect and being hidden behind other buildings, work is going ahead to make the castle site more accessible to the public.

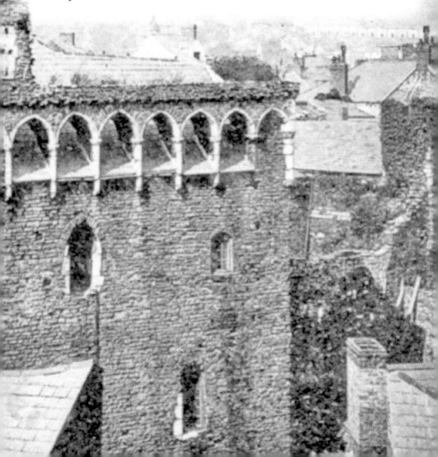

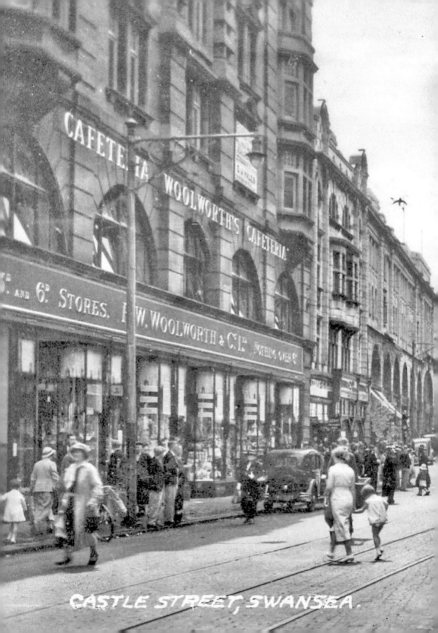

CASTLE STREET, SWANSEA.

26. CASTLE STREET, LOOKING SOUTH

Castle Street is a continuation of High Street, and eventually leads into Castle Bailey Street. This area was devastated during the Blitz, although Woolworths maintained their presence on the corner of Welcome Lane for many years after the war.

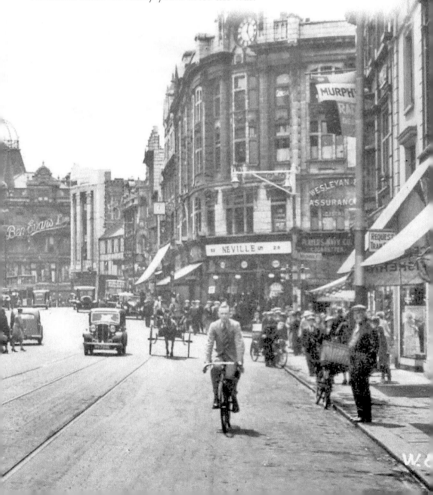

27. THE KARDOMAH CAFÉ IN CASTLE STREET

In the 1930s this iconic eatery was the haunt of a bohemian group of friends known as the 'Kardomah Boys', which included Dylan Thomas and Vernon Watkins. In Thomas' words, it was 'razed to the snow' during the Blitz. Charles Fisher, the last surviving 'Kardomah Boy', died in 2006.

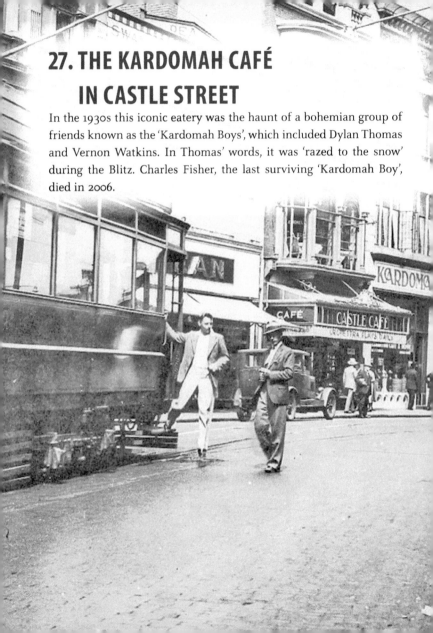

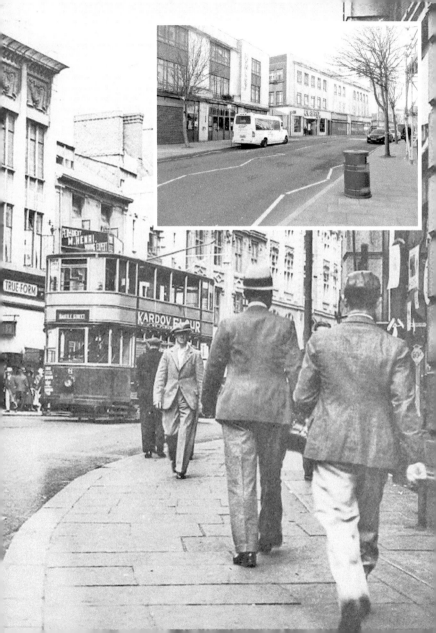

28. CASTLE BAILEY STREET

Castle Bailey Street is a short street that links Castle Street with Wind Street. As its name suggests, it lies close to the castle wall. The Gothic-style tower fronting the castle was opened as Swansea's new head post office in 1858 and continued in that role until 1901, when a larger head post office was opened in Wind Street. The building later became the offices of the *South Wales Evening Post*, and was finally demolished in 1970.

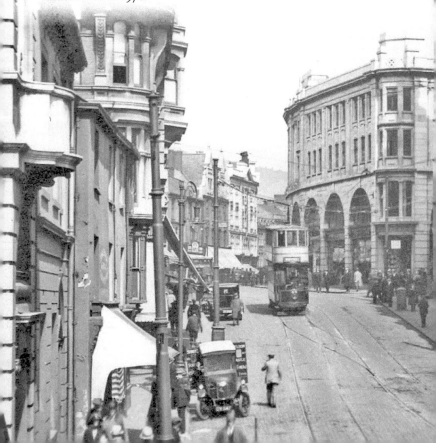

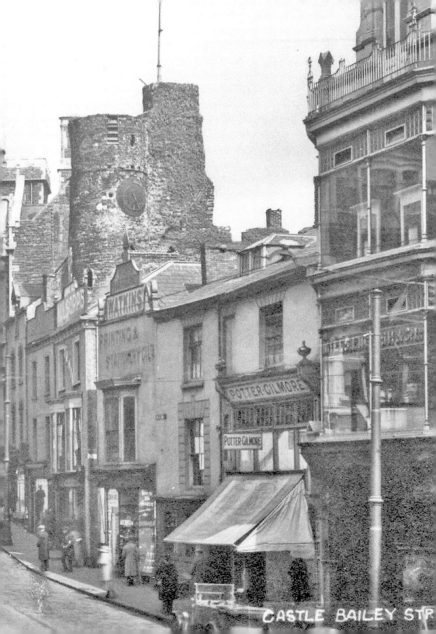

CASTLE BAILEY STR

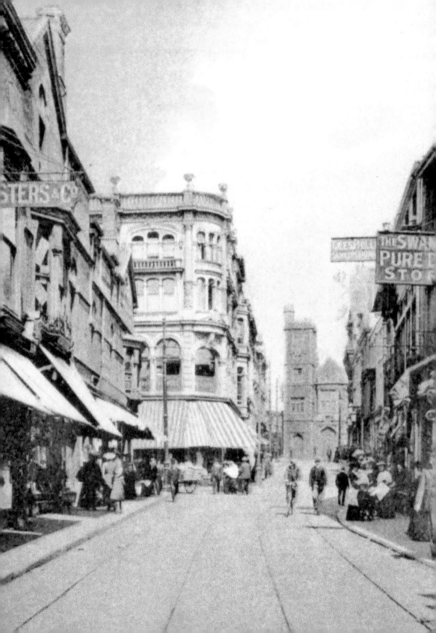

29. TEMPLE STREET

Temple Street ran from the junction of Castle Bailey Street and Castle Street down to the junction of Oxford Street and Goat Street. Ben Evans store occupied much of the southern side of the street. Today, the street is just a wide pavement, with Castle Gardens on the southern side, and Zara, Slaters, and the Office on the northern side. The Office is a bar, with seating outside.

30. WIND STREET

Wind Street is one of the original medieval streets of Swansea, known in Tudor times as Wyne Street, which best reflects the pronunciation of the name. It was here in the late nineteenth century and early twentieth century that most banks established their local head offices, creating a street of substantial office buildings. Today, it is the heart of the clubbing scene, and most of the office buildings have become pubs, clubs and places to dine.

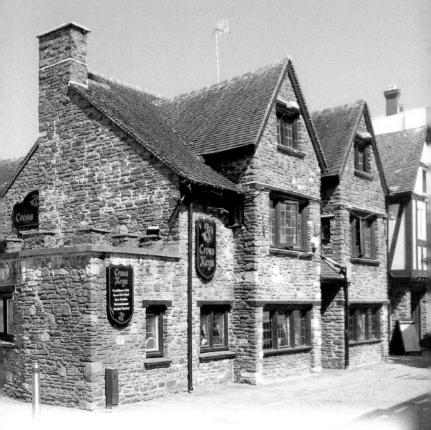

31. CROSS KEYS INN

Built in 1332 as the Hospital of the Blessed David of Swansea, the Cross Keys Inn is the oldest surviving occupied building in the city. It has been altered and expanded over the years, but at its core remains a medieval building. It also makes claim to be the oldest public house in Wales.

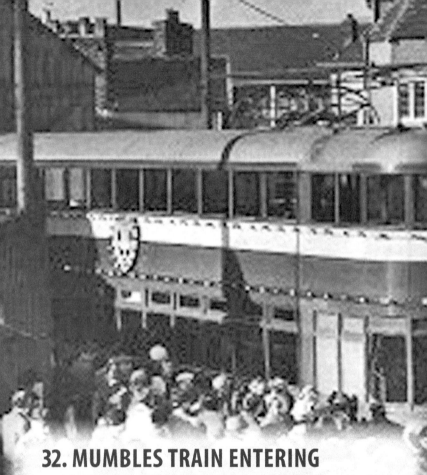

32. MUMBLES TRAIN ENTERING ITS SHED AFTER ITS LAST RUN

The Swansea and Mumbles Railway was the first railway in the world to carry fare-paying passengers. It enjoyed enormous popularity during its lifetime, but was closed in 1960. The site of its shed at Rutland Street is now occupied by St David's multistorey car park and the surrounding buildings. (Courtesy *South Wales Evening Post*)

BERNARD HASTE

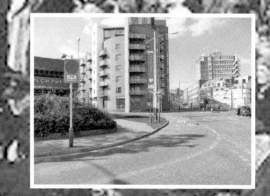

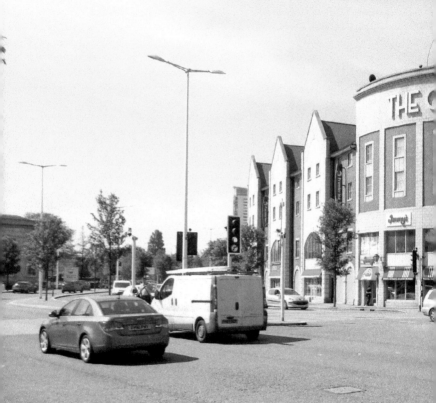

33. CITY GATES

This recent development at the bottom of Wind Street incorporates restaurants, a hotel and nightclub. Originally called Salubrious Place, after a nearby lane, the name was changed as few people, especially visitors, understood what the old name meant.

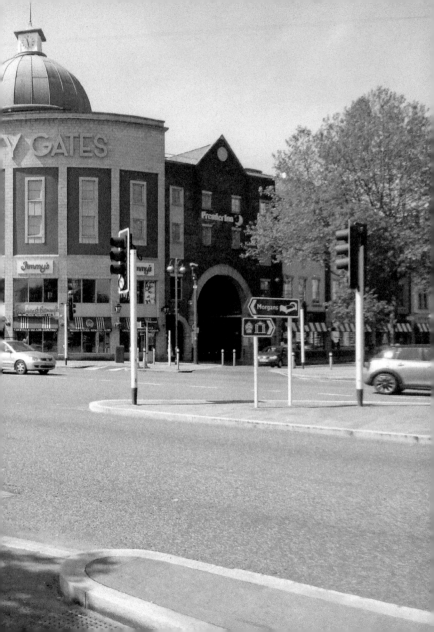

34. NORTH DOCK

The North Dock was created in 1852 by diverting the River Tawe along a new cut. The bow of the river that was left became the new dock. The dock closed in 1930 as the larger docks that had been built on the east side of the river provided better facilities. The dock was subsequently, filled in and in the 1980s the Parc Tawe retail park, along with Plantasia, was built on the site.

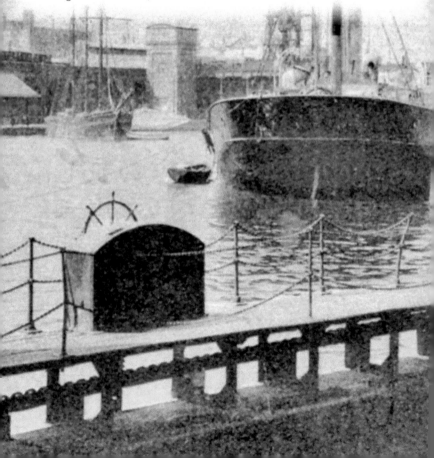

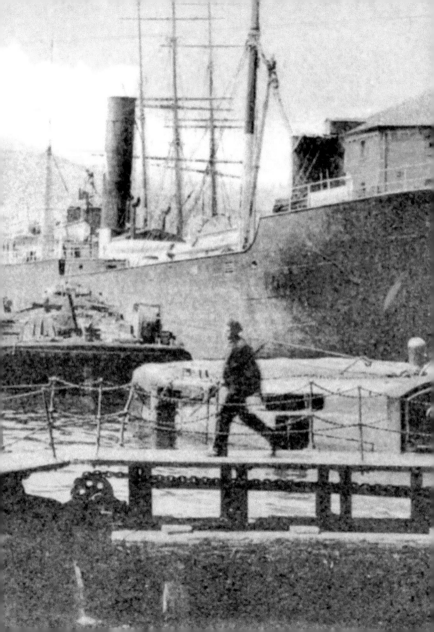

35. NORTH DOCK DRAWBRIDGE

This bridge crossed the entrance to the North Dock, with the dock itself on the left-hand side and the basin on the right-hand side. Weaver's flour mill dominates the area, as it had buildings on both sides of the road. Along the left-hand side can also be seen the high-level railway line that linked Swansea Victoria station with Swansea High Street station. Today, all this has gone, to be replaced by Quay Parade and the two bridges across the river.

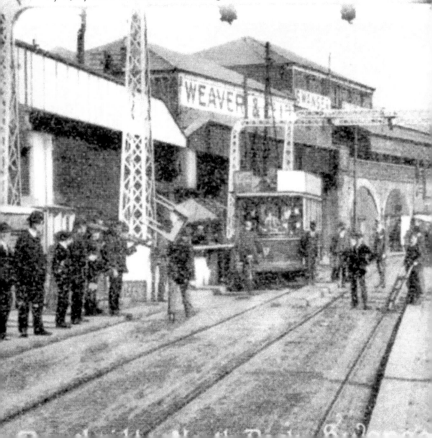

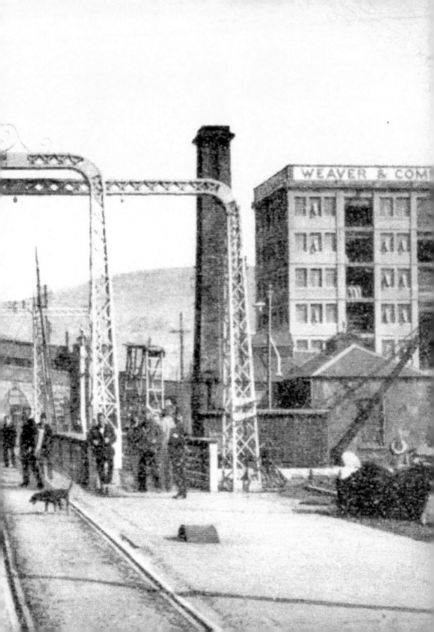

36. SAIL BRIDGE

Just past the Sainsbury's supermarket, and as part of the SA1 redevelopment project, a new footbridge has been built. The Sail Bridge was opened in June 2003 and was designed specifically to an emblem of the regeneration of the area.

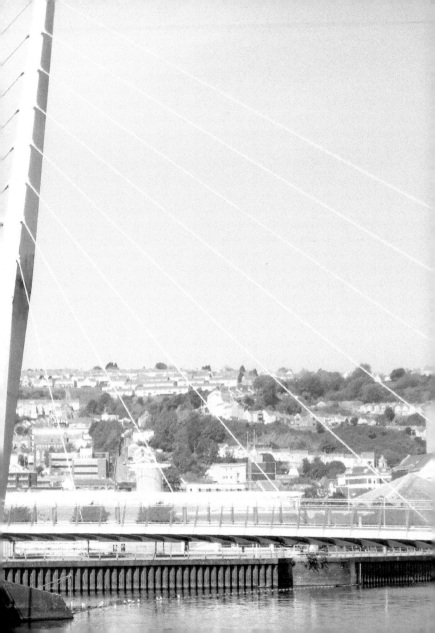

37. J SHED

Originally a commercial warehouse serving Swansea Docks, J Shed has been redeveloped to combine urban living and commercial use, with units on the ground floor including cafes. The Sail Bridge links J Shed with the western side of the River Tawe, making the area easily accessible by foot. Remain on this side of the river and walk towards the river mouth. This has been paved all the way to the Barrage, where it is possible to cross the river again. Carved into the stone en route are the names of the fishing boats that operated from Swansea at the height of the fishing industry here. The sheer number of names tells how busy the port was.

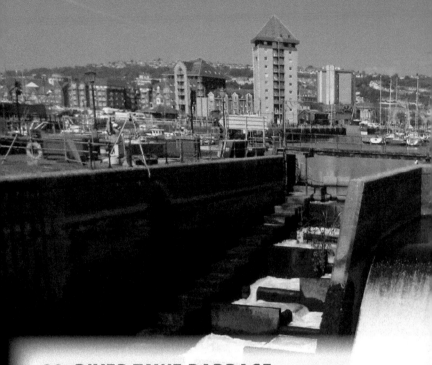

38. RIVER TAWE BARRAGE

The Swansea Harbour Trust was formed in 1791 to 'repair, enlarge and preserve the Harbour of Swansea'. Its first action was to widen and deepen the channel that formed the entrance to the harbour. Today, the Port of Swansea comprises essentially the Kings Dock, with the Prince of Wales Dock at the heart of the SA1 development, and Queens Dock largely redundant. However, the growth of the leisure boating scene in Swansea and the success of the marina at the old South Dock led to moves to make the River Tawe more boating friendly. The Swansea Barrage (or Tawe Barrage) was completed in 1992 and created a second marina at the mouth of the river.

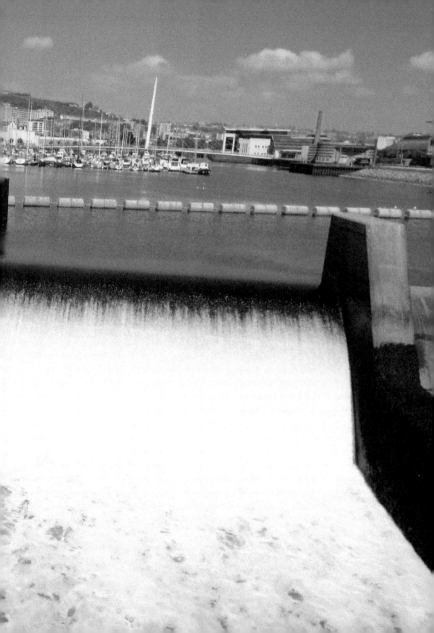

39. OLD TOWN HALL

In 1825 it was decided that a new town hall was needed, and the site selected was in the area known as the Burrows. Work was completed in 1829, but by 1848 the building was deemed too small, and was enlarged into the building we now see. The statue of John Henry Vivian and the two Russian cannons captured during the Crimean War were later additions. Today, the building has been renamed the Dylan Thomas Centre and hosts exhibitions and events.

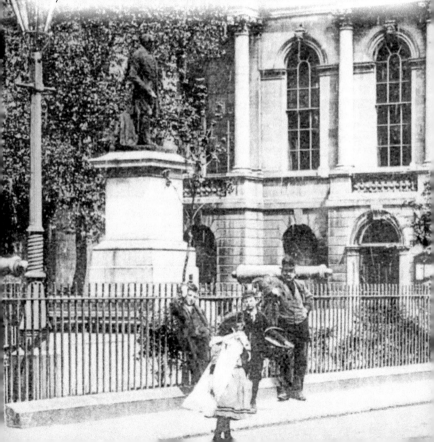

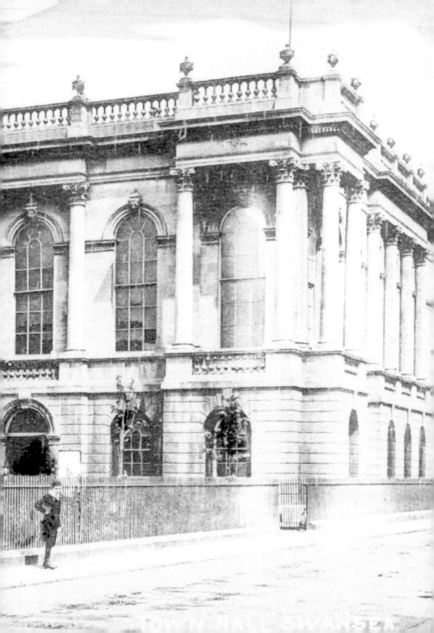

TOWN HALL SWANSEA

40. SWANSEA MUSEUM

The Swansea Philosophical and Literary Society was founded in 1835 with the aim of researching and collecting information on a wide variety of topics, and then sharing it with others. They built the Swansea Museum to display the items they had collected, create a library, and have a lecture theatre so that public lectures could be held. The museum was transferred in 1991 into the care of Swansea City Council.

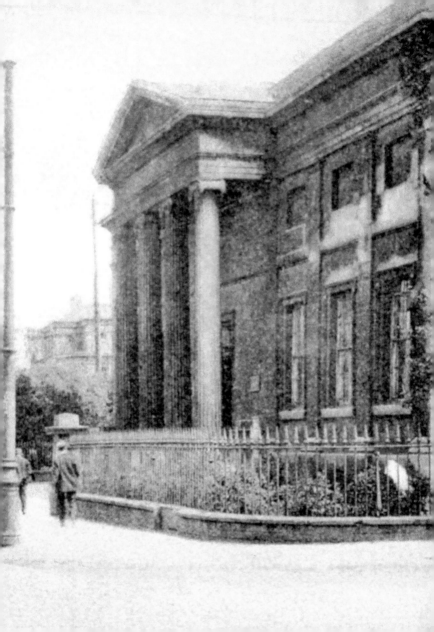

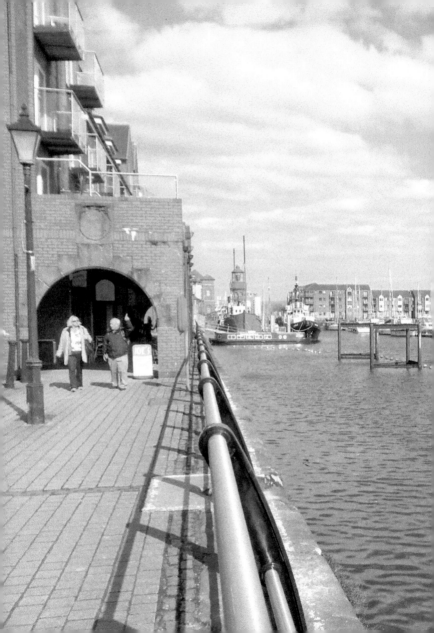

41. SOUTH DOCK

The South Dock was closed in 1971 and was earmarked for filling in and redevelopment. However, new proposals for the creation of a marina, which would help to expand the tourist potential of Swansea, were met with approval. The dock was cleared of debris and refilled to become the popular yacht haven and residential area it is today.

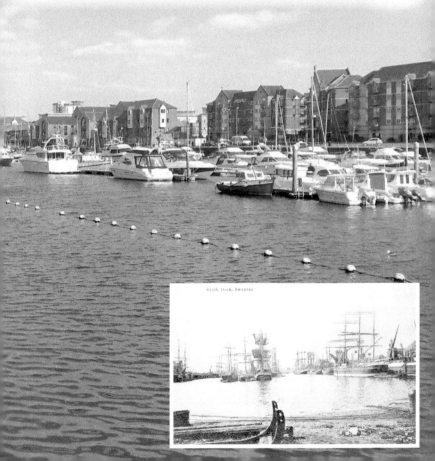

South Dock, Swansea

42. SOUTH DOCK ENGINE HOUSE

Construction of the South Dock began in 1852. It was initially undertaken by a private company but the Harbour Trust had to take over the work, which continued until 1859. The engine house provided power for the lock gates, and although the chimney stack has gone, the building still stands, and is now the Pump House restaurant.

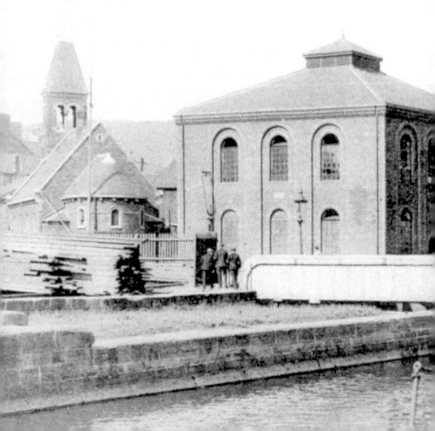

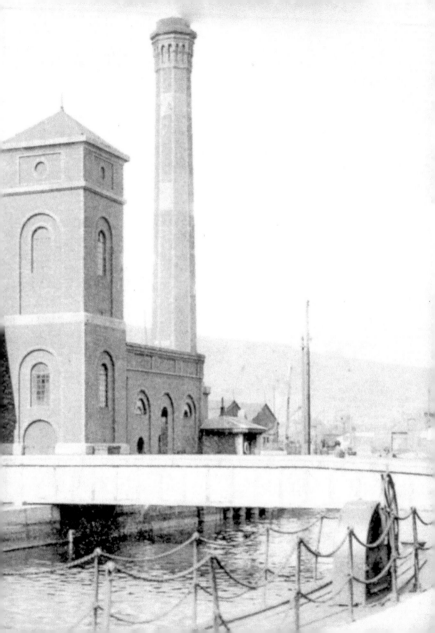

43. WATERFRONT MUSEUM

Occupying the one remaining original warehouse on the dockside of the South Dock, the National Waterfront Museum is part of the National Museum of Wales. Entry is free and there is a wide range of exhibits charting the industrial and social development of Wales.

44. MERIDIAN TOWER

Completed in 2008, the Meridian Tower (or more accurately, the Tower on Meridian Quay) is the tallest building in Wales. It has twenty-nine storeys, with the Grape and Olive restaurant occupying the top three. The remainder are devoted to residential accommodation.

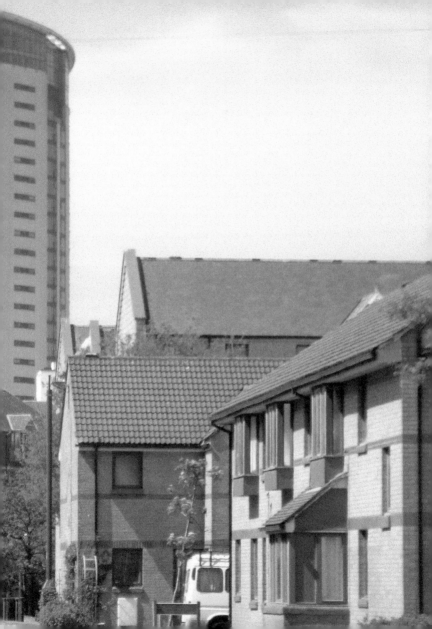

45. LC2

The LC2 Leisure Centre occupies the site of Swansea's Victoria station, which was closed when Dr Beeching swung his axe. There had been a railway station here from 1866 when the Llanelly Railway brought its line into the town. It passed to the London and North Western Railway in 1873, and then to the London Midland and Scottish Railway at grouping in 1923.

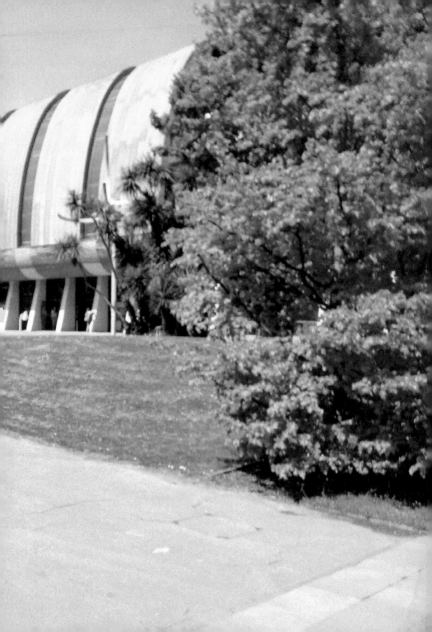